GOBLIN
MARKET

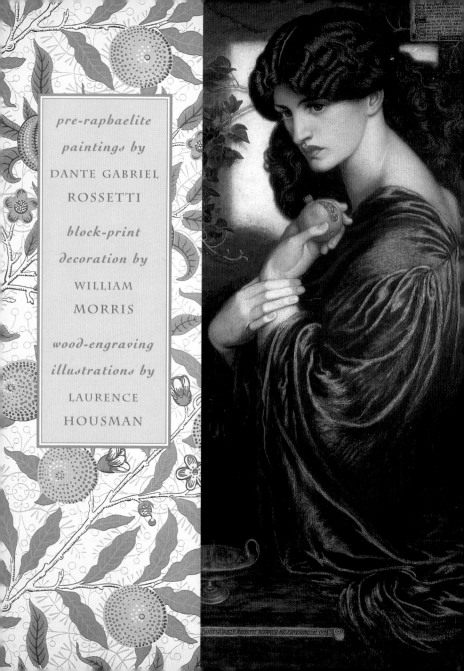

pre-raphaelite

paintings by

DANTE GABRIEL

ROSSETTI

block-print

decoration by

WILLIAM

MORRIS

wood-engraving

illustrations by

LAURENCE

HOUSMAN

DANTE GABRIELE ROSSETTI RITRASSE NEL CAPODANNO DEL 1874

GOBLIN MARKET

a tale

of two

sisters

CHRISTINA ROSSETTI

Afterword by Joyce Carol Oates

CHRONICLE BOOKS

SAN FRANCISCO

One face looks out from all his canvases

One selfsame figure sits or walks or leans:

We found her hidden just behind those screens,

That mirror gave back "all her loveliness"

A queen in opal or in ruby dress,

A nameless girl in freshest summer-greens,

A saint, an angel — every canvas means

The same one meaning, neither more nor less.

He feeds upon her face by day and night,

And she with true, kind eyes looks back on him,

Fair as the moon and joyful as the light;

Not wan with waiting, nor with sorrow dim;

Not as she is, but was when hope shone bright;

Not as she is, but as she fills his dream.

— IN AN ARTIST'S STUDIO, Christina Rossetti, 1856

PAINTINGS BY

PROSERPINE 1874 {detail, FRONT COVER; full-size, PAGE ii}. Oil on canvas, 49¾ x 24 inches. Courtesy Tate Gallery, London/Art Resource, NY.

THE DAY DREAM 1880 {PAGE 5}. Oil on canvas, 62½ x 36½ inches. Courtesy Board of Trustees of the Victoria & Albert Museum.

LA DONNA DELLA FINESTRA 1879 {PAGE 11}. Oil on canvas, 39¾ x 29¼ inches. Courtesy Fogg Art Museum, Harvard University Art Museums/Bequest of Grenville L. Winthrop.

REVERIE 1868 {PAGE 17}. Colored chalks on paper, 33 x 28 inches. Courtesy Ashmolean Museum, Oxford.

AUREA CATENA (Portrait of Mrs. Morris) 1868 {PAGE 23}. Graphite and colored pencil on paper, 30⅜ x 24⅝ inches. Courtesy Fogg Art Museum, Harvard University Art Museums/Bequest of Grenville L. Winthrop.

LA PIA DÉ TOLOMMEI 1868–1880 {detail, PAGE 29}. Oil on canvas, 41½ x 47½ inches. Courtesy Spencer Museum of Art, University of Kansas.

PANDORA 1869 {PAGE 35}. Colored chalks on paper, 39⅝ x 28⅝ inches. Courtesy Faringdon Collection Trust, Buscot Park.

PANDORA 1879 {PAGE 41}. Colored crayon on paper, 38 x 24½ inches. Courtesy Fogg Art Museum, Harvard University Art Museums/Bequest of Grenville L. Winthrop.

MARIANA 1868–1870 {PAGE 47}. Oil on canvas, 45 x 35 inches. Courtesy City of Aberdeen Art Gallery and Museums Collections.

LA DONNA DELLA FIAMMA 1870 {PAGE 55}. Colored chalks on paper, 39⅝ x 29⅝ inches. Courtesy Manchester City Art Galleries.

D. G. ROSSETTI

a tale

of two

sisters

ORNING AND EVENING

Maids heard the goblins cry

"Come buy our orchard fruits,

Come buy, come buy:

Apples and quinces,

Lemons and oranges,

Plump unpecked cherries,

Melons and raspberries,

Bloom-down-cheeked peaches,

1

Swart-headed mulberries,

Wild free-born cranberries,

Crab apples, dewberries,

Pineapples, blackberries,

Apricots, strawberries; —

All ripe together

In summer weather, —

Morns that pass by,

Fair eves that fly;

Come buy, come buy:

Our grapes fresh from the vine,

Pomegranates full and fine,

Dates and sharp bullaces,

Rare pears and greengages,

Damsons and bilberries,

Taste them and try:

Currants and gooseberries,

Bright-fire-like barberries,

Figs to fill your mouth,

Citrons from the South,

Sweet to tongue and sound to eye;

Come buy, come buy."

EVENING BY EVENING

Among the brookside rushes,

Laura bowed her head to hear,

Lizzie veiled her blushes:

Crouching close together

In the cooling weather,

With clasping arms and cautioning lips,

With tingling cheeks and finger tips.

"Lie close," Laura said,

Pricking up her golden head:

"We must not look at goblin men,

We must not buy their fruits:

Who knows upon what soil they fed

Their hungry thirsty roots?"

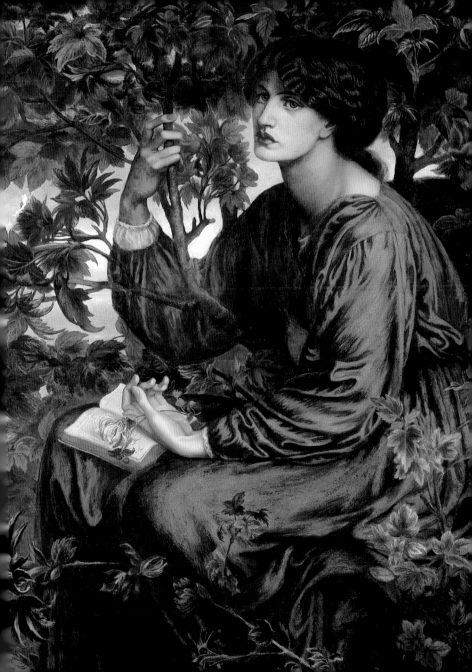

"OME BUY," CALL THE GOBLINS

Hobbling down the glen.

"Oh," cried Lizzie, "Laura, Laura,

You should not peep at goblin men."

Lizzie covered up her eyes,

Covered close lest they should look;

Laura reared her glossy head,

And whispered like the restless brook:

"Look, Lizzie, look, Lizzie,

Down the glen tramp little men.

One hauls a basket,

One bears a plate,

One lugs a golden dish

Of many pounds weight.

How fair the vine must grow

Whose grapes are so luscious;

How warm the wind must blow

Through those fruit bushes."

"No," said Lizzie: "No, no, no;

Their offers should not charm us,

Their evil gifts would harm us."

She thrust a dimpled finger

In each ear, shut her eyes and ran.

CURIOUS LAURA CHOSE TO LINGER

Wondering at each merchant man.

One had a cat's face,

One had a tail,

One tramped at a rat's pace,

One crawled like a snail,

One like a wombat prowled obtuse and furry,

One like a ratel tumbled hurry scurry.

She heard a voice like [the] voice of doves

Cooing all together:

They sounded kind and full of loves

In the pleasant weather.

Laura stretched her gleaming neck

Like a rush-imbedded swan,

Like a lily from the beck,

Like a moonlit poplar branch.

Like a vessel at the launch

When its last restraint is gone.

BACKWARDS UP THE MOSSY GLEN

Turned and trooped the goblin men,

With their shrill repeated cry,

"Come buy, come buy."

When they reached where Laura was

They stood stock still upon the moss,

Leering at each other,

Brother with queer brother;

Signaling each other,

Brother with sly brother.

One set his basket down,

One reared his plate;

One began to weave a crown

Of tendrils, leaves, and rough nuts brown

(Men sell not such in any town);

One heaved the golden weight

Of dish and fruit to offer her:

"Come buy, come buy," was still their cry.

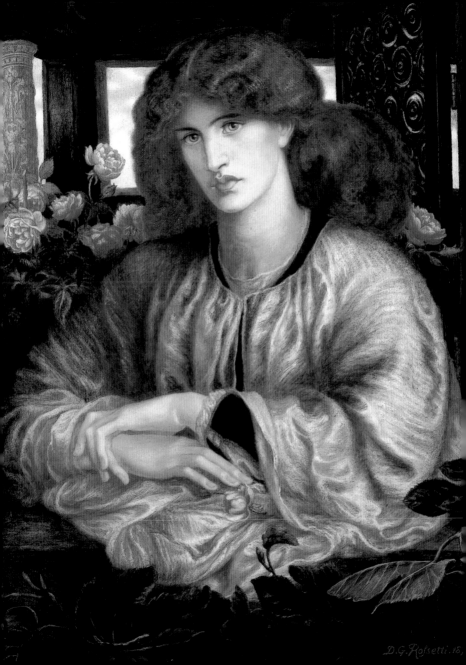

D.G.Rossetti.18

LAURA STARED BUT DID NOT STIR,

Longed but had no money:

The whisk-tailed merchant bade her taste

In tones as smooth as honey,

The cat-faced purr'd,

The rat-paced spoke a word

Of welcome, and the snail-paced even was heard;

One parrot-voiced and jolly

Cried "Pretty Goblin" still for "Pretty Polly";—

One whistled like a bird.

But sweet-tooth Laura spoke in haste:

"Good Folk, I have no coin;

To take were to purloin:

I have no copper in my purse,

I have no silver either,

And all my gold is on the furze

That shakes in windy weather

Above the rusty heather."

"You have much gold upon your head,"

They answered all together:

"Buy from us with a golden curl."

SHE CLIPPED A PRECIOUS GOLDEN LOCK,

She dropped a tear more rare than pearl,

Then sucked their fruit globes fair or red:

Sweeter than honey from the rock,

Stronger than man-rejoicing wine,

Clearer than water flowed that juice;

She never tasted such before,

How should it cloy with length of use?

She sucked and sucked and sucked the more

Fruits which that unknown orchard bore;

She sucked until her lips were sore;

Then flung the emptied rinds away

But gathered up one kernel-stone,

And knew not was it night or day

As she turned home alone.

IZZIE MET HER AT THE GATE

Full of wise upbraidings:

"Dear, you should not stay so late,

Twilight is not good for maidens;

Should not loiter in the glen

In the haunts of goblin men.

Do you not remember Jeanie,

How she met them in the moonlight,

Took their gifts both choice and many,

Ate their fruits and wore their flowers

Plucked from bowers

Where summer ripens at all hours?

But ever in the noonlight

She pined and pined away;

Sought them by night and day,

Found them no more, but dwindled and grew gray;

Then fell with the first snow,

While to this day no grass will grow

Where she lies low:

I planted daisies there a year ago

That never blow.

You should not loiter so."

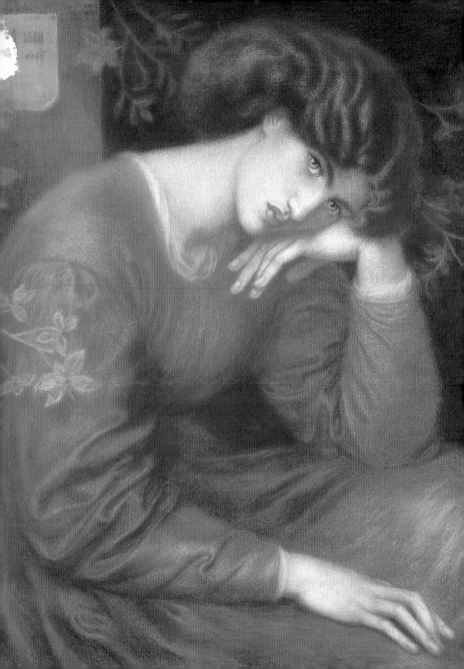

AY, HUSH," SAID LAURA:

"Nay, hush, my sister:

I ate and ate my fill,

Yet my mouth waters still;

Tomorrow night I will

Buy more," and kissed her:

"Have done with sorrow;

I'll bring you plums tomorrow

Fresh on their mother twigs,

Cherries worth getting;

You cannot think what figs

My teeth have met in,

What melons icy-cold

Piled on a dish of gold

Too huge for me to hold,

What peaches with a velvet nap,

Pellucid grapes without one seed:

Odorous indeed must be the mead

Whereon they grow, and pure the wave they drink

With lilies at the brink,

And sugar-sweet their sap."

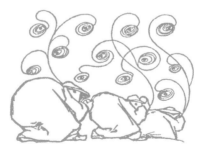

GOLDEN HEAD BY GOLDEN HEAD,

Like two pigeons in one nest

Folded in each other's wings,

They lay down in their curtained bed:

Like two blossoms on one stem,

Like two flakes of new-fall'n snow,

Like two wands of ivory

Tipped with gold for awful kings.

Moon and stars gazed in at them,

Wind sang to them lullaby,

Lumbering owls forbore to fly,

Not a bat flapped to and fro

Round their rest:

Cheek to cheek and breast to breast

Locked together in one nest.

ARLY IN THE MORNING

When the first cock crowed his warning,

Neat like bees, as sweet and busy,

Laura rose with Lizzie:

Fetched in honey, milked the cows,

Aired and set to rights the house,

Kneaded cakes of whitest wheat,

Cakes for dainty mouths to eat,

Next churned butter, whipped up cream,

Fed their poultry, sat and sewed;

Talked as modest maidens should:

Lizzie with an open heart,

Laura in an absent dream,

One content, one sick in part;

One warbling for the mere bright days delight,

One longing for the night.

T LENGTH SLOW EVENING CAME:

They went with pitchers to the reedy brook;

Lizzie most placid in her look,

Laura most like a leaping flame.

They drew the gurgling water from its deep;

Lizzie plucked purple and rich golden flags,

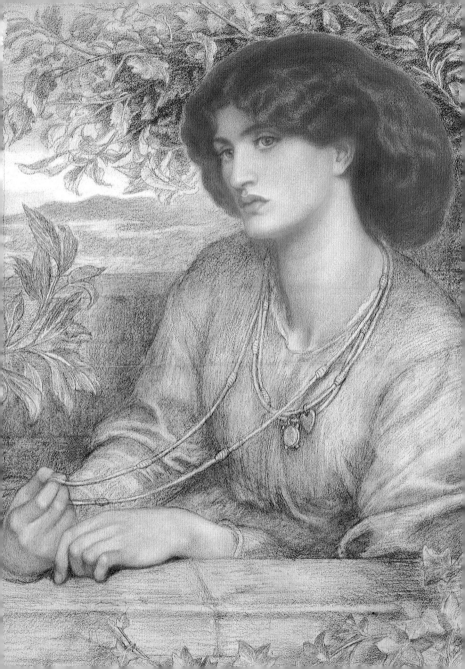

Then turning homeward said: "The sunset flushes

Those furthest loftiest crags;

Come, Laura, not another maiden lags,

No willful squirrel wags,

The beasts and birds are fast asleep."

But Laura loitered still among the rushes

And said the bank was steep.

And said the hour was early still,

The dew not fall'n, the wind not chill;

Listening ever, but not catching

The customary cry,

"Come buy, come buy,"

With its iterated jingle

Of sugar-baited words:

Not for all her watching

Once discerning even one goblin

Racing, whisking, tumbling, hobbling;

Let alone the herds

That used to tramp along the glen,

In groups or single,

Of brisk fruit-merchant men.

TILL LIZZIE URGED, "O LAURA, COME;

I hear the fruit-call, but I dare not look:

You should not loiter longer at this brook:

Come with me home.

The stars rise, the moon bends her arc,

Each glowworm winks her spark,

Let us get home before the night grows dark:

For clouds may gather

Though this is summer weather,

Put out the lights and drench us through;

Then if we lost our way what should we do?"

AURA TURNED COLD AS STONE

To find her sister heard that cry alone,

That goblin cry,

"Come buy our fruits, come buy."

Must she then buy no more such dainty fruit?

Must she no more such succous pasture find,

Gone deaf and blind?

Her tree of life drooped from the root:

She said not one word in her heart's sore ache;

But peering thro' the dimness, nought discerning,

Trudged home, her pitcher dripping all the way;

So crept to bed, and lay

Silent till Lizzie slept;

Then sat up in a passionate yearning,

And gnashed her teeth for baulked desire, and wept

As if her heart would break.

AY AFTER DAY, NIGHT AFTER NIGHT,

Laura kept watch in vain

In sullen silence of exceeding pain.

She never caught again the goblin cry:

"Come buy, come buy";—

She never spied the goblin men

Hawking their fruits along the glen:

But when the moon waxed bright

Her hair grew thin and gray;

She dwindled, as the fair full moon doth turn

To swift decay and burn

Her fire away.

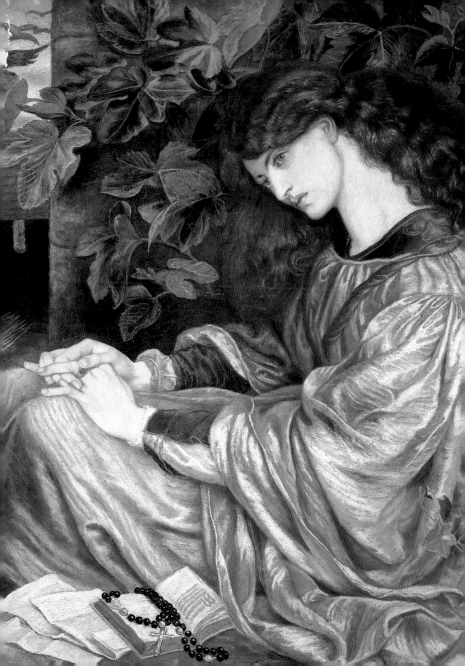

NE DAY REMEMBERING HER KERNEL-STONE

She set it by a wall that faced the south;

Dewed it with tears, hoped for a root.

Watched for a waxing shoot,

But there came none;

It never saw the sun,

It never felt the trickling moisture run:

While with sunk eyes and faded mouth

She dreamed of melons, as a traveler sees

False waves in desert drouth

With shade of leaf-crowned trees,

And burns the thirstier in the sandful breeze.

She no more swept the house,

Tended the fowls or cows,

Fetched honey, kneaded cakes of wheat,

Brought water from the brook:

But sat down listless in the chimney-nook

And would not eat.

ENDER LIZZIE COULD NOT BEAR

To watch her sister's cankerous care

Yet not to share.

She night and morning

Caught the goblins' cry:

"Come buy our orchard fruits,

Come buy, come buy":—

Beside the brook, along the glen,

She heard the tramp of goblin men,

The voice and stir

Poor Laura could not hear;

Longed to buy fruit to comfort her,

But feared to pay too dear.

She thought of Jeanie in her grave,

Who should have been a bride;

But who for joys brides hope to have

Fell sick and died

In her gay prime,

In earliest wintertime,

With the first glazing rime,

With the first snowfall of crisp wintertime.

ILL LAURA DWINDLING

Seemed knocking at Death's door:

Then Lizzie weighed no more

Better and worse;

But put a silver penny in her purse,

Kissed Laura, crossed the heath with clump of furze

At twilight, halted by the brook:

And for the first time in her life

Began to listen and look.

LAUGHED EVERY GOBLIN

When they spied her peeping:

Came towards her hobbling,

Flying, running, leaping,

Puffing and blowing,

Chuckling, clapping, crowing,

Clucking and gobbling,

Mopping and mowing,

Full of airs and graces,

Pulling wry faces,

Demure grimaces,

Cat-like and rat-like,

Ratel- and wombat-like,

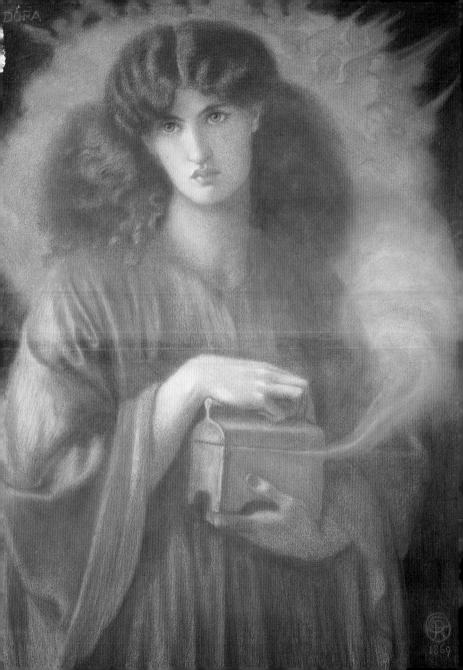

Snail paced in a hurry,

Parrot-voiced and whistler,

Helter skelter, hurry scurry,

Chattering like magpies,

Fluttering like pigeons,

Gliding like fishes,—

UGGED HER AND KISSED HER:

Squeezed and caressed her:

Stretched up their dishes,

Panniers, and plates:

"Look at our apples

Russet and dun,

Bob at our cherries,

Bite at our peaches,

Citrons and dates,

Grapes for the asking,

Pears red with basking

Out in the sun,

Plums on their twigs;

Pluck them and suck them,

Pomegranates, figs."—

OOD FOLK," SAID LIZZIE,

Mindful of Jeanie:

"Give me much and many":—

Held out her apron,

Tossed them her penny.

"Nay, take a seat with us,

Honor and eat with us,"

They answered grinning:

"Our feast is but beginning,

Night is yet early,

Warm and dew pearly,

Wakeful and starry:

Such fruits as these

No man can carry;

Half their bloom would fly,

Half their dew would dry,

Half their flavor would pass by.

Sit down and feast with us,

Be welcome guest with us,

Cheer you and rest with us."—

 39

HANK YOU," SAID LIZZIE: "BUT ONE WAITS

At home alone for me:

So without further parleying,

If you will not sell me any

Of your fruits though much and many,

Give me back my silver penny

I tossed you for a fee."—

HEY BEGAN TO SCRATCH THEIR PATES,

No longer wagging, purring,

But visibly demurring,

Grunting and snarling.

One called her proud,

Cross-grained, uncivil;

Their tones waxed loud,

Their looks were evil.

Lashing their tails

They trod and hustled her,

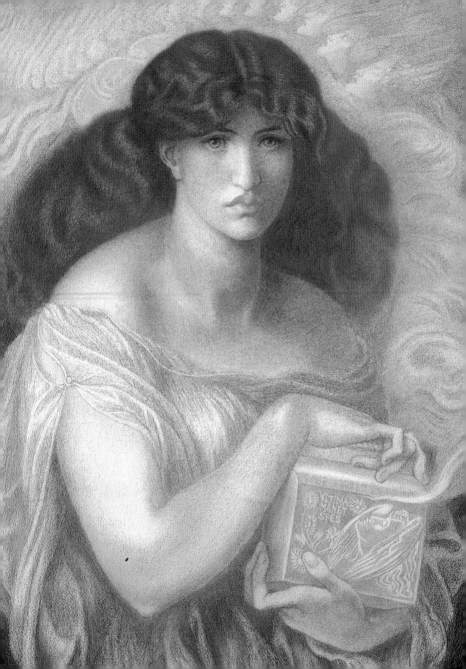

Elbowed and jostled her,

Clawed with their nails,

Barking, mewing, hissing, mocking,

Tore her gown and soiled her stocking,

Twitched her hair out by the roots,

Stamped upon her tender feet,

Held her hands and squeezed their fruits

Against her mouth to make her eat.

HITE AND GOLDEN LIZZIE STOOD,

Like a lily in a flood,—

Like a rock of blue-veined stone

Lashed by tides obstreperously,—

Like a beacon left alone

In a hoary roaring sea,

Sending up a golden fire,—

Like a fruit-crowned orange tree

White with blossoms honey-sweet

Sore beset by wasp and bee,—

Like a royal virgin town

Topped with gilded dome and spire

Close beleaguered by a fleet

Mad to tug her standard down.

NE MAY LEAD A HORSE TO WATER,

Twenty cannot make him drink.

Though the goblins cuffed and caught her,

Coaxed and fought her,

Bullied and besought her,

Scratched her, pinched her black as ink,

Kicked and knocked her,

Mauled and mocked her,

Lizzie uttered not a word;

Would not open lip from lip

Lest they should cram a mouthful in:

But laughed in heart to feel the drip

Of juice that syrupped all her face,

And lodged in dimples of her chin,

And streaked her neck which quaked like curd.

T LAST THE EVIL PEOPLE,

Worn out by her resistance,

Flung back her penny, kicked their fruit

Along whichever road they took,

Not leaving root or stone or shoot;

Some writhed into the ground,

Some dived into the brook

With ring and ripple,

Some scudded on the gale without a sound,

Some vanished in the distance.

IN A SMART, ACHE, TINGLE,

Lizzie went her way;

Knew not was it night or day;

Sprang up the bank, tore thro' the furze,

Threaded copse and dingle,

And heard her penny jingle

Bouncing in her purse,—

Its bounce was music to her ear.

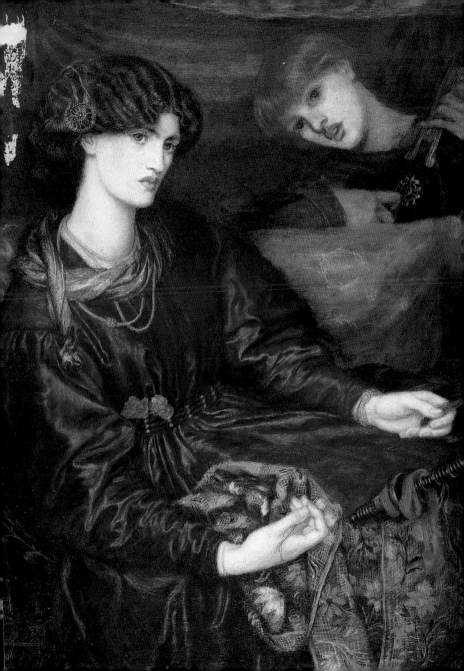

SHE RAN AND RAN

As if she feared some goblin man

Dogged her with gibe or curse

Or something worse:

But not one goblin scurried after,

Nor was she pricked by fear;

The kind heart made her windy-paced

That urged her home quite out of breath with haste

And inward laughter.

She cried, "Laura," up the garden,

"Did you miss me?

OME AND KISS ME.

Never mind my bruises,

Hug me, kiss me, suck my juices

Squeezed from goblin fruits for you,

Goblin pulp and goblin dew.

Eat me, drink me, love me;

Laura, make much of me;

For your sake I have braved the glen

And had to do with goblin merchant men."

LAURA STARTED FROM HER CHAIR,

Flung her arms up in the air,

Clutched her hair:

"Lizzie, Lizzie, have you tasted

For my sake the fruit forbidden?

Must your light like mine be hidden,

Your young life like mine be wasted,

Undone in mine undoing,

And ruined in my ruin,

Thirsty, cankered, goblin-ridden?"—

She clung about her sister,

Kissed and kissed and kissed her:

Tears once again

Refreshed her shrunken eyes,

Dropping like rain

After long sultry drouth;

Shaking with aguish fear, and pain,

She kissed and kissed her with a hungry mouth.

ER LIPS BEGAN TO SCORCH,

That juice was wormwood to her tongue,

She loathed the feast:

Writhing as one possessed she leaped and sung,

Rent all her robe, and wrung

Her hands in lamentable haste,

And beat her breast.

ER LOCKS STREAMED LIKE THE TORCH

Borne by a racer at full speed,

Or like the mane of horses in their flight,

Or like an eagle when she stems the light

Straight toward the sun,

Or like a caged thing freed,

Or like a flying flag when armies run.

Swift fire spread through her veins, knocked at her heart,

Met the fire smoldering there

And overbore its lesser flame;

She gorged on bitterness without a name:

Ah! fool, to choose such part

Of soul-consuming care!

SENSE FAILED IN THE MORTAL STRIFE:

Like the watchtower of a town

Which an earthquake shatters down,

Like a lightning-stricken mast,

Like a wind-uprooted tree

Spun about,

Like a foam-topped waterspout

Cast down headlong in the sea,

She fell at last;

Pleasure past and anguish past,

Is it death or is it life?

Life out of death.

53

HAT NIGHT LONG LIZZIE WATCHED BY HER,

Counted her pulse's flagging stir,

Felt for her breath,

Held water to her lips, and cooled her face

With tears and fanning leaves:

But when the first birds chirped about their eaves,

And early reapers plodded to the place

Of golden sheaves,

And dew-wet grass

Bowed in the morning winds so brisk to pass,

And new buds with new day

Opened of cup-like lilies on the stream,

Laura woke as from a dream,

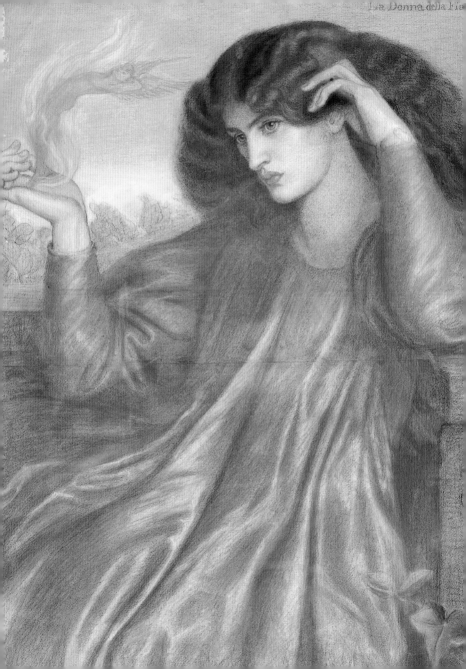

La Donna della Fia

Laughed in the innocent old way,

Hugged Lizzie but not twice or thrice;

Her gleaming locks showed not one thread of gray

Her breath was sweet as May

And light danced in her eyes.

AYS, WEEKS, MONTHS, YEARS

Afterwards, when both were wives

With children of their own;

Their mother-hearts beset with fears,

Their lives bound up in tender lives;

Laura would call the little ones

And tell them of her early prime,

Those pleasant days long gone

Of not-returning time:

OULD TALK ABOUT THE HAUNTED GLEN,

The wicked, quaint fruit-merchant men,

Their fruits like honey to the throat

But poison in the blood;

(Men sell not such in any town):

Would tell them how her sister stood

In deadly peril to do her good,

And win the fiery antidote:

HEN JOINING HANDS TO LITTLE HANDS

Would bid them cling together,

"For there is no friend like a sister

In calm or storm weather;

To cheer one on the tedious way,

To fetch one if one goes astray,

To lift one if one totters down,

To strengthen whilst one stands."

AFTERWORD
JOYCE CAROL
OATES

afterword

THE RIDDLE OF CHRISTINA ROSSETTI'S
GOBLIN MARKET

NOTHING IN THE LIFE AND CAREER OF CHRISTINA ROSSETTI (1830–1894) quite prepares us for the astonishing ballad-like poem *Goblin Market*. A younger sister of the celebrated Pre-Raphaelite painter and poet Dante Gabriel Rossetti, known for her Christian Anglican piety and admired by her contemporaries for such exquisitely wrought but conventional poems as the the sonnets *After Death, The World, Dead Before Death,* and *Cobwebs*, Rossetti fashioned in *Goblin Market* an exotic, gorgeously written poem that shimmers with meanings like a dream of uncommon subtlety. The poem is five hundred sixty-seven lines long, Rossetti's longest and most formally ambitious piece of writing; its rhymes are startling, original, rather childlike in affect, with the disturbing, disingenuous musical cadences of the nursery rime throughout. Stresses are emphatic, even harsh: *"Morning and evening / Maids heard the goblins cry: / 'Come buy our orchard fruits, / Come buy, come buy:"* When rhymes and stresses are purely symmetrical, the

❤ *61*

tone is teasing, even taunting: *"Pineapples, blackberries, / Apricots, strawberries; — / All ripe together / In summer weather."* For this is the Goblin Men's special language, mock-lyric, meant to taunt, tease, disconcert and seduce.

Goblin Market is as much a riddle as a poem of artful ambiguities. It will remind readers of such dreamlike predecessors as Samuel Coleridge's *Christabel* (with the snaky-seductive vampire Geraldine) and John Keats's *La Belle Dame Sans Merci* (a ballad of the tragic meeting of a young knight and a fairy seductress) and *The Eve of St. Agnes* (an elaborately composed narrative poem of Spenserian stanzas greatly admired by the Pre-Raphaelite Brotherhood to which by propinquity and temperament Christina Rossetti was attached) — works which, for all their genius, fail to communicate the immediacy of erotic (or frankly sexual) yearning evoked in certain stanzas of *Goblin Market*. The Romantic poets imagine seduction from a masculine perspective, but Rossetti's perspective is distinctly female, achingly specific. The vulnerable sister, Laura, she who is seduced by the Goblin Men, is imagined as *"a vessel at the launch / when its last restraint is gone."* Laura's complicity in a

violation that will be both physical and spiritual is expressed in language of uncommon directness, startling in a poem of its time: *"She sucked and sucked and sucked the more / Fruits which that unknown orchard bore, / She sucked until her lips were sore; / Then flung the emptied rinds away."* As a reading experience, *Goblin Market* is irresistible. Its quickened, breathless rhythms and eccentric rhymes with their air of improvisation draw in the reader at once.

Goblin Market & Other Poems was published in 1862 to critical acclaim, establishing Christina Rossetti's reputation in London literary circles. Its immediate appeal for Victorian readers would have been for its sensuous, suspenseful story, with its ballad-like unfolding; the literary ballad being a popular verse-form usually involving relatively unsophisticated simple characters. Its moral appeal, a Victorian necessity, is clearly, perhaps too clearly for contemporary tastes, stated in the concluding stanzas: *"For there is no friend like a sister / In calm or stormy weather; / To cheer one on the tedious way, / To fetch one if one goes astray, / To lift one if one totters down, / To strengthen whilst one stands."* (The very voice of *"wise, upbraiding"* Lizzie

who speaks for Victorian morality, conscience and rectitude of the kind satirized by Lewis Carroll in *Alice in Wonderland* and *Alice Through the Looking-Glass,* 1865, 1871.)

For contemporary readers, it is the elusive subtext of *Goblin Market* that seizes our imaginations, provoking us to wonder at the poem's more subtle and possibly more subversive meanings. As sympathetic feminist critics have noted, *Goblin Market* is an inspired, original female reworking of the old misogynist myth of the Biblical Garden of Eden, Eve's weakness, temptation and fall, the subsequent loss of paradise, the sacrifice of a personal savior, and redemption. (Where the old myth enters its final phase, there is no redemption.) The poem bears an obvious thematic relationship with such myths as the tale of Pandora's box (in which yet another curious, imprudent female unleashes horrors upon herself and the world by an act of impulsive disobedience) and the European fairy tale of Bluebeard (in which numberless curious, imprudent brides of Count Bluebeard meet their grisly fate by opening a door in his castle he has forbidden them to open). There is no suggestion in *Goblin Market,* however, that Laura has, in the end, lost anything of

value. Rossetti doesn't imagine a Miltonic "fortune fall" but simply a fall, and a miraculous redemption; and a return to the idyll of sisterhood from which Laura temporarily strayed. And what wonderfully bizarre tempters the Goblin Men are: no hallucinatory visions out of Carroll's *Alice* books are more comic-grotesque and chilling: *"One had a cat's face, / One whisked a tail, / One tramped at a rat's pace, / One crawled like a snail, / One like a wombat prowled obtuse and furry, / One like a ratel tumbled hurry scurry. / She heard a voice like [the] voice of doves / Cooing all together."* (How particularly uncanny that, though the Goblin Men are plural, their seductive voice is singular.)

"Sweet-tooth Laura" eagerly exchanges a *"precious golden lock"* from her head (her priceless virginity?) for the Goblin Men's forbidden fruit which she devours, in fact *"sucks,"* more greedily than any other female in literary history, including even the mythic mother of all our sorrows, the Biblical Eve. Lizzie, Laura's good twin, *"full of wise upbraidings,"* awaits her at home, seeming to know beforehand what Laura had done, and the danger that lies in store for her. For Laura has been

seduced not only by the Goblin Men's exquisite fruits but by her own repressed, unacknowledged sexual appetite as well, which mesmerizes her: *"I ate and ate my fill, / Yet my mouth waters still . . . / You cannot think what figs / My teeth have met in."* Soon, Laura is *"longing for the night"* while Lizzie, uncontaminated by the taste of Goblin Men's fruit, is content, even oblivious of the night; Laura is *"like a leaping flame"* while the prudent Lizzie is *"most placid in her look."*

Repudiated by the Goblin Men who have seduced her, as, in Victorian terms, a woman, once fallen, was likely to be repudiated by the very man who had seduced her, Laura begins to pine away: *"Her tree of life drooped from the root."* She endures the night *"in a passionate yearning. / And gnashed her teeth for balked desire, and wept / As if her heart would break."* Except in frankly pornographic work, no one of Christina Rossetti's time whether male or female could have written directly of sexual desire; women were generally believed, in fact, to have no sexual or erotic desire. But Laura of *Goblin Market* finds herself trapped in the throes of such desire, taking no solace any longer in the domestic idyll in which she and her sister have

lived like innocent children. Only when Lizzie ventures out into the *"haunted glen"* to purchase fruits for Laura at the price, nearly, of being violated herself, is Laura revived, and saved.

Lizzie's fierce virginity confronts the Goblin Men's primitive rapacity in an astonishing scene that must have been disturbing to Victorian readers: *"Their tones waxed loud, / Their looks were evil. / Lashing their tails / They trod and hustled her, / Elbowed and jostled her, / Clawed with their nails, / Barking, mewing, hissing, mocking, / Tore her gown and soiled her stocking, / Twitched her hair out by the roots, / Stamped upon her tender feet, / Held her hands and squeezed their fruits / Against her mouth to make her eat."* But, *"like a royal virgin town"* (an apt metaphor for the Age of Queen Victoria, the dowager-virgin) Lizzie holds fast; Lizzie cannot be violated by male force. An exemplary feminist heroine, *"Lizzie uttered not a word; / Would not open lip from lip / Lest they should cram a mouthful in: / But laughed in heart to feel the drip / Of juice that syrupped all her face, / And lodged in dimples of her chin, / And streaked her neck which quaked like curd . . . / In a smart, ache, tingle, / Lizzie went her way; / Knew not was it night or day."* Lizzie returns to

the languishing Laura, her beloved sister, whom she invites to *"Eat me, drink me, love me; / Laura, make much of me."*

The denouement of the poem has a fairy tale logic, however implausible and unconvincing its narrative terms: Laura *"kissed and kissed and kissed [Lizzie] with a hungry mouth"* and sucks the Goblin Men's juices from her, experiencing an exorcism of the juices' power over her. The redeeming life Lizzie brings to Laura is an antidote to the original poison, as, perhaps, in Rossetti's Christian imagination, the sacrifice of Jesus Christ is an antidote to mankind's original sin, the eating of the forbidden apple and the disobeying of God the Father. The exorcism as Rossetti describes it is richly erotic; sensual and intimate, wringing *"Life out of death."* And the poem ends in a coda of rejoicing in a future time *"when both were wives / With children of their own"* and the perils of the *"wicked quaint fruit-merchant men"* have long been vanquished. The terrible *"poison in the blood"* of ungovernable sexual desire is but a memory, a familiar tale the sisters tell their children. (Of the sisters' presumed husbands we see and hear nothing: Lizzie and Laura would seem to be virgin mothers.)

This is a somewhat forced, very Victorian-moral conclusion to a teasing, provocative riddle of a poem. For *Goblin Market* evokes questions it does not answer. Who are the Goblin Men? Why precisely are their fruits delicious, yet dangerous and forbidden? And why are there no human men in the sisters' world? Why is Laura susceptible while Lizzie, her virtual twin, is not? Why, after Laura's seduction, do the Goblin Men immediately withdraw from her? Why isn't it possible for Laura to repeat her sensual experience? (Is Rossetti implying that a woman's fall from chastity and her initial experience of intense sexual pleasure would preclude her from re-experiencing it? But why? However ostracized a fallen woman might be from proper Victorian society, she could surely have had lovers. And the degree of ostracism would be relative: as a chaste middle-class Victorian spinster, Christina Rossetti herself became a volunteer worker at St. Mary Magdalen Home for Fallen Women on Highgate Hill — a final, ironic footnote to *Goblin Market*.) Is the relationship between male and female little more than a cruel game on the part of the male, who would appear to risk nothing in the transaction except a loss of

sperm? Or are the Goblin Men not meant to suggest men at all but merely beasts, their appeal exclusively to bestial/sexual desire? How seriously is the reader to take Rossetti's final vision of a matrilineal and matriarchal world in which the highest value is sisterhood? It is difficult to believe that the sisters' original state, in which they sleep *"Cheek to cheek and breast to breast / Locked together in one nest,"* is a more desirable state than that of mature sexual experience; but, given the peculiarly limited terms of Rossetti's world in this poem, what can possibly constitute female maturity?

Like most powerful poetry, *Goblin Market* eludes absolute meanings. It remains a haunting aesthetic creation very like the lush, dreamlike, technically accomplished and ornamental romantic mystic art of the Pre-Raphaelite Brotherhood with which Christina Rossetti was associated; the poem is enhanced by the vivid, sensuous images of Dante Gabriel Rossetti that express so poignantly the soul's urgent and unspeakable yearnings.